# The Rain at Midnight

# The Rain at Midnight

Poems by

# Joseph Hutchison

Sherman Asher Publishing

©Joseph Hutchison, 2000
All rights reserved. Except for brief quotations in critical articles or reviews, no part of this book may be reproduced in any form or by any means electronic or mechanical, including photocopying, recording, or by any informational storage and retrieval system, without permission in writing from the publisher.

Acknowledgments:
The author gratefully acknowledges the publications in which some of these poems, often in different versions, first appeared. A list appears on page 96.

Cover Design: Janice St. Marie
Book Design: Judith Rafaela
Cover Photograph: Jack Kotz "Rain on Hogback"
Printed in the United States of America

First Edition
ISBN 1-890932-12-4

Library of Congress Cataloging-in-Publication Data

Hutchison, Joseph.
    The rain at midnight : poems / by Joseph Hutchison.-- 1st ed.
    p. cm.
    ISBN 1-890932-12-4 (pbk.)
    I. Title.

PS3558.U834 R35 2000
811'.54--dc21                                    00-024189

Sherman Asher Publishing
PO Box 2853
Santa Fe, NM 87504
*Changing the World One Book at a Time*™

*For my parents,
Joe and Helen*

*and for Melody*

# Contents

### One: St. Failure's Hospital

The Shower ........................................................... 11
The Tremor ........................................................... 12
Family Planning .................................................... 14
Harbinger ............................................................. 15
Sundown .............................................................. 16
Punishment .......................................................... 17
Another Middle-Aged Deity ................................. 18
Daffodils ............................................................... 19
The Dreamers ...................................................... 20
Forgone Conclusions ........................................... 21
An Amusing Anecdote ......................................... 22
Good ..................................................................... 23
Three Male Voices ............................................... 24
One Way Fare ...................................................... 26

### Two: The Oldest Fear

Masks .................................................................... 29
Radiance ............................................................... 30
The One-Armed Boy ............................................ 31
Strange But True .................................................. 32
Something More ................................................... 34
Vita ....................................................................... 36
White Owl ............................................................ 37
Sandman ............................................................... 38
Evening on Loveland Pass ................................... 39
Palimpsest ............................................................ 40
Apartment House Midnight .................................. 41
Bare Maple ........................................................... 42
Dusk ..................................................................... 43
Christmas Parade ................................................. 44

### Three: Net of Flaws

The Net ................................................................. 47
A Natural History ................................................. 48
A Beach North of Depoe Bay ............................... 49
Bending Over My Reflection ................................ 50
Blossoms .............................................................. 51
Scene from a TV News Special Report on the P.L.O. .......... 52
Night Storm .......................................................... 53

Remedies ............................................................................. 54
Walking Off a Night of Drinking in Early Spring ............... 55
One Wave ............................................................................ 56
What Keeps Me Here ......................................................... 57
Internal Combustion .......................................................... 58
What I Know ....................................................................... 59
After All These Years .......................................................... 60
Instructions Received in a Dream ..................................... 61
Black River .......................................................................... 62

## Four: The Eye's Reach

The Cloud and the Kingdom ............................................. 65
Self-Assessment .................................................................. 67
The Whisper ........................................................................ 68
Forced to Wonder ............................................................... 69
Bronze Bud Vase in the Shape of an Iris Bulb with
    Swordlike Leaves .......................................................... 70
The Ghost ............................................................................ 71
The Dyer's Craft .................................................................. 72
The Moonlit Dream ............................................................ 73
Outing on a Grey Day ........................................................ 74
On a Used Copy of Witter Bynner's Translation of the *Tao
    Teh Ching* ...................................................................... 78

## Five: Brightness and Shadow

Dawn Rain ........................................................................... 81
Seduction ............................................................................. 82
Standing By ......................................................................... 83
The Blue ............................................................................... 84
After the Service ................................................................. 86
Flashes .................................................................................. 87
Starlings ............................................................................... 88
Daybreak .............................................................................. 89
A Midsummer Night's Tennis Match ............................... 90
Brightness and Shadow ...................................................... 91
Summit ................................................................................. 92
Glassbottom Boat ............................................................... 93
The Rain at Midnight ......................................................... 94
Notes to the Poems ............................................................ 95

## Author's Note and Acknowledgments

I did not want to go,
not yet, nor knew what to do
if I should stay, for how

in that great darkness could I explain
anything, anything at all.
I stood by the fence. And then

very gently it began to rain.

*— Hayden Carruth,
from "The Cows At Night"*

# One: St. Failure's Hospital

# The Shower

Lying awake is bad. But worse
is rising in the dark before dawn
to shower. The house hushed,
cold, half-foreign: can it be

you live here? And the stairs
wander sleepily under your feet
as they climb you down, lead you
to a fiberglass basement stall

where the water's loudness
won't reach and wake the family.
Under the spray, you always feel
you're not all there. And true,

your scrubbed body *is* vanishing,
cell by cell…down the drain.
And the steaming, lover-like rain
whispers to your bones, *Come clean.*

## The Tremor

Waking at 3 A.M.—the bed shuddering
under him, as if in convulsion—he bolts
awkwardly to his feet, grabs the edge
of the dresser for balance.
                          And her voice
lands like ice water. "What's wrong?
What is it now?"
                          "Nothing," he tells her.

"Come back to bed, then."

He carries himself to the kitchen first,
for a quick, cold drink. The floor's
steady, the window-pane
a slab of coal he stands staring into,
gripping his vodka. Outside, the dog's
begun to whimper…awakened
by the crackling of ice cubes,
or something beyond…?

There's a tremor
few others seem to feel.

And maybe it's only his own.

                          *

    You can read too much news. *Quake Hits 6.9 On The Richter Scale. Two Children Die In Idaho.*
    He sees them walking to school, brother and sister, sees them stop by the corner drug and peer in at the old-fashioned fountain: Green and Red Rivers, sundaes, malts; on the wall, Evelyn Nesbit sips her Coke in the shade of an apple tree.
    He stood at that window once, in Twin Falls. August, everything he owned in a Volkswagen van. Stood recalling how, as a kid, he'd peered through

such fly-specked glass at the racks of magazines the law kept him from—though he'd often slip in for a peek. Nipples like dollops of pink whipped cream; moist lips; tanned bottoms and the shadowy pelvic cradles. Old Lady Huenecker would cough...so he'd hang-dog to a fountain stool and stammer, "Chocolate soda" or "Raspberry ice," savoring the tremor....

In Twin Falls he swayed with the same quickening, shut his eyes, caught his breath. Sure—he could wander from town to town, all his worldly goods in a rickety van. Why not? There was a deathless vibration in his blood....

As he thinks of it, the girl in Idaho cocks her head, glances up at her brother. And the sidewalk shrugs, the window bellies and bursts: the drugstore wall comes down.

A broken Thermos bottle, a brass coat button, wince amid the rubble....

*

Today, the earth in Idaho is quiet;
one more wave of its becoming has passed.
The dead in Idaho are more than quiet.
The noise his kids make, squabbling
over breakfast, is music.
                                  From the patio,
he peers through the shadowy kitchen window
at his wife gliding from fridge to stove,
stove to table, table to sink....

*Only my own*, he thinks, scooping nuggets
of dry chow into a bowl. But the dog,
as if she'd heard his thoughts—or
something beyond—cocks her head, stares
up at him with her amber eyes shining,
and whimpers....

# Family Planning

A few whiskies into the moping hour
he can almost make himself faint
with the memory: his doctor fishing
for that elusive vas deferens, snagging
it—giving it a quick, hard twist. Christ!
He hadn't known those strings fastened
to his eyeballs in back, where the ends
spat like frayed powerlines, making sweat
shower over him like sleet. "Does it hurt?"
crooned the doctor. Snip-snip. "There,
didn't feel a thing, did we." *We*?
He shook his head manfully, spinning
only a moment into the roaring blackness.

But really it had been mostly painless—better
than putting his wife through major surgery,
the gas alone a hazard. Besides, this way
he could drive himself home and lie back
with an ice-pack on his plum-colored scrotum,
letting her pamper his ache like a geisha.
Every three hours she crept to his bed
with tea and a pill, beaming at his proof
that the other woman was gone for good.
(*It* was *proof*, he muses, splashing the Irish
into his glass.) Having nothing to offer
but pleasure, the years ahead seemed clear.
Everything was clearer then. Wasn't it?

# Harbinger

An unknown bird, dark
as lightning's after-image,
picks at the vacant air
and twitters. The twig it grips,
soaked by winter rain, shakes
down a drop
onto my cheek.
That song…I've never
heard it before. But the chill of it
sluicing my silvery bones—this
I know by heart.

# **Sundown**

A globe of fire-glue drooped
from the tube's end: white
hot, then yellow-orange,
then orange as it plumped
with the glassblower's
meticulous breath. It seemed
the turning shaped his airy

gift, the way the world shapes
how we know it. "The sun's
going down" isn't so, but even
astronomers say it; as even those
who can't love find themselves
whispering, "I'll love you
always." *Always*, said the glass

in a crackly voice as it cooled.
*Always*, it cried years later,
shattered by anger in a year
of loss. *Always*, I find myself
thinking as I write…gazing
out the darkening window,
watching the sun go down.

## Punishment

Two lovers with no future
going at it: the bed's headboard
bumps the wall, hung upon which
Van Gogh's manic *Irises* knocks

gently; nails sunk into studs
and plaster grow a little looser.
Such punishment is why the house
will collapse someday, the world

being what it is: a planet
full of lovers with no future—
only *now*, *now*—and that famous
"it" all of them keep going at.

# Another Middle-Aged Deity

> *There's not a man that lives*
> *who hath not known his godlike hours.*
> —Wordsworth, "The Prelude"

He fears he's coming unhinged,
but really the door was long ago
ripped from its wall and cast out
into the river. All these years

he's sailed the black current,
peeling his sunburn. Peeling it,
feeding skin to catfish massed
and writhing around his raft,

as if every penis on earth awoke
in one vagina. Oh, the stink
of that hunger! Which feeding
only seemed to make worse. Yet

he fed them. Not to catch them—
how eat a creature whose moustache
flickers, so fastidiously waxed?
But because their convulsions,

their gaped mouths and avid,
obsidian stares, made him feel
godlike. And he *was* God to them!
"This is my body," he'd whisper.

But now his friends correct him:
"Bodies are symbols. Love, a door—
right only if hinged in a wall."
He gnaws his tongue to agree.

Oh yes, a house is what matters.
A house built high above the river.
A house from which to watch the river
teeming and stinking at a safe distance!

18

# Daffodils

Let's speak of anguish at the root
of daffodils, their open-mouthed
breathlessness. Let's meditate upon
stones that still dream of the magma,
and the fever in each atom (its disease
of desire to keep those particles
circling and circling). Let's consider
the shout that leaps in a sleeper's throat
like a fountain, and the way the bone
you'll break in a stumbling fall at seventy
already whimpers with cold foreknowledge.
Let's convene an expert commission
to study the effects of despair
on sowbugs, a panel for every fly,
whole armies of pollsters collecting
the opinions of nits and viruses.

I feel a bit ill.
                      No, I'm really okay.

But there's a nagging ache in my chest,
a germinating bruise where the lungs
lay side by side like failing lovers,
breathing-in anguish, breathing-out
anguish, breathing without hope
that anything gets easier or sweeter.
Let's talk about how sick we've become
of breath. Let's be honest. Let's admit
there's a limit and we're near it.
Let's stop pretending. Let's lie down
in the dirt and blossom in silence.
Let's open our mouth and shut up,
in imitation of daffodils.

# The Dreamers

In St. Failure's Hospital, every ward
is chilly and all the cases terminal.
The solitary nurse's white shoes pant
upon the linoleum, although it's no use:
however she calms them, the patients rise
at 2 A.M. and sleepwalk in their fevers,
believing there must be exits. Their sheets
peel back, rustling like November leaves,
and the poor nurse rushes bed to bed
like a wind. How it hurts! Hearing
those dreamers getting up in the dark.

# Forgone Conclusions

> *In the house of the dead
> are many cradles.*
> —Ted Hughes

What is that rocking? A slung weight
among the crossbeams of the ribs,
and a mewling like wind in the cracks of a wall.
What fabled baby ekes out its creaturely music there?

I woke in terror when that infant fist let fall
its snake's-tail rattle—
seeds that shot black creepers
through my guts.

Now breathless, listening,
I fear this keening's my life foretold.
Oh my lumpkin, my secret whimperer—
who am I to insist on calm?

Your crying swaddles my speech like a caul,
I shudder like leaves with your longing.
Longing for what? And what bright-eyed shadow
kneels beside your rocking cradle?

# An Amusing Anecdote

Why did she want to see me now
that our divorce is final? I thought
she would imitate stone, but all
through lunch she's been talkative.
Something about a painting I believe
I've never seen (though she swears
we viewed it together, years ago,
at an Exhibition of Thulean Masters).
Something, too, about the rain—
mention of which sets me trembling, as if
suddenly soaked to the bone. (I can still
hear the shower curtain shrieking
as she rakes it back, remember how
savagely that girl from the office
shrank away behind my shoulder.)
Sucking at my daiquiri, I notice
she's adding milk to her tea—
something she didn't learn from *me*.
(Tea with milk unraveling in it,
like fraying threads of a galaxy, always
reminds me of Northern Europe: Streets
chilled, glistening; a black, polished car
hisses by…"The Third Man Theme"
bleeding from the dashboard radio; fingers
writhing from a sewer grate!) Just then
she laughs, mouth wet. The waiter
has brought our bill—and by mistake
I'm wielding it like a dwarf's bandanna,
mopping the sweat from my eyes.

# Good

I might have gone on with my heart in a pouch,
as a little boy hoards his favorite marble.
I might have gotten used to dining on crumbs,
living on the faintest taste: many have done it.

I might have learned to see in the dark, if dimly.
I might have learned to disremember the dreams
of tornados, and blasted tree limbs, and floods.
I might have learned to keep smiling for no reason.

I might have denied myself your kiss, your caress.
I might have sneered, "What's happiness worth?"
I might have let my duties define my desires.
I might have hurt no one. I might have been good.

# Three Male Voices

<center>1</center>

Ears flaring red, I'd dive
backward to the floor,
kick and wail. And Mama
would bend to gather me up
sometimes, and sometimes
slap with the flat of her hand,
and sometimes land a fist.
Still, in the end, Mama
always gathered me up,
held me hard against her.

<center>2</center>

What can a man do with the ball
of barbed wire inside his chest?

Call it a heart.
Give it to women.

Let them drop it, the bitches!
Let their mangled hands bleed.

3

I was lifted, sleeping,
like floating on calm water.
Strong, quiet breathing.
We moved through woods.
My legs were so long, dangled
so far down, that my feet
dragged in the black grass.
We moved under leaves,
moonlight splashing
across my closed eyes.
Just before waking
I opened them wide
and gazed a long time
upward at the stony face
of the child who carried me.

## One Way Fare

In an old coat's pocket,
a crumpled Greyhound ticket.
Why I was leaving, I forget—

but the number inked on one edge
wakens a lost phone, a voice
that once meant something:

almost saved me, I think. Now
that whole time's like deep
pondwater blurred by wind; feels

like roadside fog that hides
looming woods, or a clear
view of mountains far away.

# Two: The Oldest Fear

## Masks

As a child he tried on
dozens of masks,
kept three or four that almost fit.
Wearing them made his face-bones ache,
but he'd found that if you're known
anything can happen.

Many years and many
aches later, she peered into him—
*saw* him. One by one, the masks dissolved.
Sweet relief! Then a rush of darkness,
his oldest fear:
anything can happen.

# Radiance

The wind stilled, and the sway
of the treehouse stopped. The boy
sat against one splintery wall,
dozing over the pink, dimpled nudes
in the magazine he'd stolen. His flesh
was ripe with summer, his gaze heavy
as it wandered up from the pages
in his lap and came to rest on
what loomed in the window: a far,
ineffable sheen; then a ghostly oval;
then a saucer made of milky glass;
then the very body of radiance.
The light impacted below his navel
startled out of him suddenly in three
quick jets, soaked his cutoffs—almost
knocked him flat. So that he stared
into the slowly cleaving breast
of the cloud, and laughed in delight
because of the radiance, and wept
as well because he could feel
the bleeding in his mind.

# The One-Armed Boy

has taught himself to play catch
with the walls of his house.
With great difficulty has learned
to open jars, trap grasshoppers,
write in straight lines. Has,
over time, discovered how
not to hear his mother weeping,
or his father roaring drunk.
Has carefully trained himself
to deflect the cutting
comments of his schoolmates.
If only a saw had gnawed it off!
Or some gigantic shark, as in
his recurring fantasies. If only
he hadn't been born like this.
And yet, near sleep, the arm
that never was reaches out,
touches something even the boy
can't name. Like rain at midnight
falling into a field of poppies, it
gently bathes his non-existent hand.

## Strange But True

The asphalt unrolls out of the gray-dirt
flatness daubed with weeds, two lanes queasy
with August heat. Cranked halfway down,
all the windows shudder. The boy's bare feet,
propped on the dash, bathe in the hot gush
from the open wing (this is before conditioned
air, spring-loaded cupholders, stereo FM).
It's late morning, eighty miles from Dubois,
Wyoming.
          Father and son left Denver at dawn
to fish the Wind River, where (they both
know) the boy will barely wet his hook
before the boredom takes over…his casts
turn sloppy, the snags more frequent; his father
will scold, they'll fight; the boy will end up
in the car alone, sullenly thumbing the lurid
paperback he'd bought for a buck in Cheyenne:
*Strange But True*.
          At this moment, though,
peace. The boy can't sleep, but keeps nodding
off into states of suspension; the wind's boom,
the motor's drone, the road's throaty roar
melt and run together in his skull
until his brain's steeped in warm honey;
so that, when his father speaks, the words
float in from far off like sprays of milkweed—
glimmering, buoyant, faintly surprising
(they've driven in silence for over an hour):
"I wonder," he says, "where the rubber goes
that wears off the tires."

                          A mystery
they ponder for a breath or two—then both
grin, start to laugh...until the laughter
floods them with wakefulness, makes
the whole vagueness of Wyoming shift
into focus: flaking highway lines the color
of old mustard, greenish bursts of sage,
phone wires and fences loping by, mountains
thick and blue in the distance...and all of it
shining in their watering eyes as they fly—
laughing, father and son—through summer
and the summer of their lives: strange but true.

## Something More

He came home smashed.
Seventeen. Shirt and jeans
nubbled with the oddments

of an August evening spent
face-up under a wheeling
willow tree. His buddies

had pressed the full-moon
glow of the doorbell button,
taken off. Then a skewed

square of livingroom light
opened around him. He
swayed...squinted at her

pinched frown, her blue eyes
scaldingly astonished. "Mom,"
he mumbled, and hauled

the screendoor wide, wobbled
on in. "You'd better get out
of those things," she said.

Next he knew, he'd spilled
his bones into the woozy bed.
But he'd barely started down

the churning spiral into sleep
when a burst of brightness
thumped his shut eyes. She

sank down beside him: "Here."
She turned his ache-stabbed
forehead toward the lamp

and with her thumb tugged at
the corner of his eye. "You can't
sleep with contact lenses in,"

she reminded him. Her palm
warmed his jaw as he gazed
into her altered face; the frown

had yielded to a fiercer look:
half amusement, half pity.
Soon she'd worked out both

shards of plastic, popped them
into her cupped hand. Then
she stood and said, "There.

You sleep. You go to work
in three hours." She switched
off the light, and he watched her

step away, watched her pause
in the doorway as if to say
something more. But as ever,

she let her silence and the dark
comprehension in his heart
speak for them both.

# Vita

The heart in its bedroom
lifting weights. All muscle
like Schwarzenegger. Thinks

it's attractive. Thinks it's hot
shit. Knows what it knows
like a highschool dropout.

The heart (in full view
of the open window) hears
girls faint at the glimpse, boys

gnashing their teeth—and so
goes on lifting till gravity
wins, and the weights

crash down. After which,
sweet trembling. The heart
walled in darkness…flexing,

posing, admiring its shadow
in a mirror that never
cared less.

# White Owl

A man stares at his life and doesn't know what to do. He feels he must do something...but the car runs fine, the apartment's clean, necessary letters have been written. The leaves in his ex-wife's yard need raking—but that's another life; he needs to do something about *this* one, and he drifts from window to window looking for clues. He snaps the radio on, then off; picks up a pen, and puts it down. A few whiskies later he nods off in front of the ball game, misses seeing the Cowboys beat the Redskins, though he hears distant battle sounds as he crawls through the forest. He's muddied his face because the moon is full. Thin black boughs lash his cheeks. Somewhere nearby, as a boy, he buried a cigar box full of treasures—and sure enough, a little digging under a willow brings it to the surface: White Owl. But the box is empty. Someone's been here ahead of him, like grave robbers at the pharaoh's tomb. The moon sinks beyond a ridge. The noise of battle swells. On the box lid the owl shuffles its snowy feathers, uttering a warm bassoonlike note...the familiar pronoun...utters it with great weariness, as if to say, "So—what more did you expect?"

## Sandman

I'm up at midnight, sleepless, hunting
for the sandman in a tumbler of whiskey,
neat. But really, not so neat. I've never

"needed" drinks till these last few months,
and it scares. I used to know how to kiss
my scars asleep with a sigh, or by walking

them up and down like fussy babies, or
shutting them up with a crow-like laugh;
knowing that love was a waste of breath,

I taught myself how not to breathe. But
she's made me forget all that—so that now
the pain's gotten too big for its britches;

I can't even get the dumb fucker drunk.
And the sandman? He's taken a powder
with a rolled-up five and wants to talk,

talk, talk about his sleepless life. Well,
what can I do? I hug him like a brother.
I let him cry on my shoulder till dawn.

# Evening on Loveland Pass

A low sun kindles the pale
trunks of ten thousand aspen.
They shine forth under the green
flesh of their leaves, below
battered cliffs, scoured peaks,
the wind-torn skies of August.
They burn the way a man does
once every year, if he's lucky;
if not, every five or ten. Myself,
I have to reach all the way back
to a kiss that filled my bones
with a sift of fireflies, my heart
with a doomed elation. Ever since,
I've felt the dusk coming down
like that shadow on the mountain.
It touches the topmost leaves, then
darkens the whole grove: nothing
but shreds of cloud still lit.

## **Palimpsest**

He caught sight of some letters
scraped into a cottonwood's trunk
and stopped to read. But the scars
had almost healed into the bark.
*Lovers*, he mused, touching them.
Blur upon blur. The savage erasures.

## Apartment House Midnight

Rough wind's in the eaves,
and those quarreling voices:
torn leaves, torn lives....

# Bare Maple

Then winter came on, peeled
leaves from the red maple
like time that strips desires
from our memory, until the past
stands forth sharp and wooden

upon the blue. Now wind can't
punish the branches like regret,
making them ache, making them
cry out. Sunlight can no longer
dream through weaving boughs

and swim on the deep grass
until the grass becomes a sea.
Now there is no more shelter
for nests, no intimate rustling
to soothe our nights. Winter

has plucked every brightness
from the gray limbs, left
but a scrawl on the emptiness
like an ideogram that means both
"forgetfulness" and "peace."

# Dusk

Midwinter twilight,
and this urge to open

my coat to the wind.
So I do. I let the cold

worm under my shirt,
creep over my ribcage;

I let it count the bars.
And dusk deepens,

dyes the clouds
of my breath:

no way to stop it—
the darkness I mean.

## Christmas Parade

Here we are, standing by the hundreds
downtown and in wintry darkness,
waiting for the Christmas parade.
Along the avenue bare trees glitter,
tangled in colored lights; office towers

like cruise ships upended in arctic water.
And a young girl—black tights, stiletto
heels, thin baggy sweater—drifts by,
drugged or drunk, one hand flung out
now and then to lampposts, bus benches,

crutches of parking meters. Up close,
her pupils are ink blots, bullet holes; she
glares as if to drawl, "Fuck you very much,"
then founders in the crowd. Blocks away,
a marching band launches its brassy

*Joy to the World*...which we hear
without irony, because all of us
want it, can't seem to catch hold of it—
joy, I mean—and our reaching for it seems
to unbalance even as it steadies us, as we

drift forward to watch the parade.

# Three: Net of Flaws

# The Net

Time unfurls a net of flaws. It whirls
above our wave, then sinks with a hiss.

Who can outswim its swift descent?
The net embraces all, draws all

up into the killing element—this
hour, this now—whose light insists

that we acknowledge what we are.
We thrash against it. Our bodies

shine, our eyes expand; we kiss
for everything light can't give us.

Thrash and kiss. Thrash and shine.

# A Natural History

I went down to the sea.

I watched it sharpen
salt teeth on the rocks.

Tide pools stared at the sky,
photographed my face.
Then, night after night,

I could feel the anemone
feeding in my chest—
red swallow, red
excretion...those soft

devouring kisses. I've passed
eons as a mouth, muscular
flower of cold hunger.

What bones I have
are made of that salt.

Whoever I embrace I eat.

# A Beach North of Depoe Bay

The ebb has bared the under-rocks:
pitted, scored, smoothed. Starfishes
cramp on gnarls, stretch or crumple
in the folds; and pale anemones,
like torn Japanese lanterns, waver
in pools, make silky knots if prodded.
The ocean's a wonder, but its plenty
sharpens my sense that nature is
a squander: no one thing worth much.
So that my heart imitates this urchin
under its rib of basalt—bristling
against whatever touch may come
to single it out, wanting nothing
but the flood again, its brutal lift
and cradling anonymity again....

## Bending Over My Reflection

The tide pool still, a hand's-depth of crystal,
its black basalt floor gnarled like a brain.
Crabs spider into crevices and out—scant ghosts
waking a swarm of shudders under the water's skin.

## Blossoms

The deep awareness like green wood, moist under its armor of bark. Here what began as fetid groundwater is clear and fragrant; the wood soaks it up and dreams, making white blossoms open in the wind. And the pressure of their whiteness in your mind makes the wind rise, until the green wood bends and aches....

Then the blossoms shower down. A few cling to gnarls in the bark; others settle through tangled grass, feeding the sodden ground. But many alight on the cold river rushing nearby and are swept along like faintly lit faces in a speeding bus...the night coming on....

You see how your face is a kind of blossom. That's why you're rootless and easily wounded...and why you'll never know what the green wood knows.

## Scene from a TV News Special Report on the P.L.O.

Here is the shingle beach where,
in front of her father, Palestinians
shot a three-year-old Israeli girl.

The camera pans, zooms out; a salt
wind shudders in the hand-held mic.

How clean the bare stones look now!
And look how firm our reporter stands
as the waves stagger in beyond him.

# Night Storm

The moon pinched
between gables: a shriek
in a dreamer's throat,

or a blossom of dogwood
pasted by the howling
wind onto the wet

sky, glassy and black.
Clouds stream over it,
hiding the stars now,

now unveiling their
trembling thorns.
Branches lash

in the dark—and what
bends them back is what
we want to capture,

what we want to lift
us up....But it's clear
we can touch only traces:

thorns in the distance,
torn petals, cries
in a dream.

# Remedies

To kill hiccups, sip a little water from the wrong side of a glass. Slowly, the knot in your chest uncoils. Air comes and goes, followed by a somber calm: you recall an epileptic childhood friend who drowned in her bath...how you pitied the circular arguments in her body....

Suddenly, your hiccups return, more violent. Sugar will not work, nor breathing your own wasted breath from a bag. Only some shock can bring you back: your likeness on the mirror's wrong side, for example, twitching just under the surface.

# Walking Off a Night of Drinking in Early Spring

    for Joe Nigg

Through the budding elm branches, eyes
of traffic lights blink red to green;
the idled traffic surges forward in the dark—

and we stagger on down the alley, joyful,
voices loud and cloudy in the cold.
Where do these hours come from? Hours

when old wounds flare, and the night
opens, and pain boils up into conversation,
as if talk can heal. The sweating bottle

drifts hand to hand, mouth to mouth—
and stars blink through branching clouds,
the blood groping darkly in our heads;

but the moon's here, too. A bright clarity
over cars and streetlamps, over houses
and leaving trees: going with us.

# One Wave

> *...and the timid soul*
> *has her footing washed away....*
> —D. H. Lawrence, "The Ship of Death"

It seemed one wave
swept forth differently,
with a dark motive. It

hissed about my feet,
kissed at the bones,
the frigid backwash

washing packed sand
out from under them.
At times, it seems

I've never left
that shore. It seems
a wave still gushes

between my ankles,
still wills me
toward the deep;

my toes still clutch,
aching—and I stagger:
I dance for solid ground.

## What Keeps Me Here

How long have I knelt
in the tall grass, gazing
into this broad river's
rushing smoothness?

I look up: the light is
changed, the firs secretive,
their shadows everywhere.
What keeps me here?

I lean toward the stillness
in the current. Bones of rock!
Dark radiance in the clear
flesh of the waters.

# Internal Combustion

I'm a responsible man, and so
they load me up. Seems they think
I'm a truck with a big engine,
thick tires, strong shock absorbers:
a little gas, some water, battery acid—
they think it keeps me happy.

But it happens I'm also a lamp
with a chimney of glass
and a bellyful of golden spice-oil.
It happens my tongue is a wick,
and when the longing
flames out from my furnace heart,
I speak, and those who listen
burn. Or I don't speak:
I swallow the fire,
and it sinks down writhing
in my scrotum like some demon.

It's that demon who lights my way.
The demon they name if they mention me.
The demon who drives me around in circles,
roaring like hell, eating my own sweet dust.

# What I Know

Tears creep down the upturned face.
*My* face, although it seems I see it
from across the room. It seems
that I approach the bed and gaze
at the weeping man lying there. I am
sorry about his loneliness and fear,
but I know they will diminish
toward morning when sleep
comes at last. The pillow will be
damp and cold, but sleep will come.

Why, I wonder, can't my knowledge
comfort him? After all, he is me
and suffers only because he refuses
to see me standing in the dark
with what I know.

## After All These Years

When I fantasize your kisses it
rattles me, like downing four
mugs of coffee in advance
of noon, making me tremble
unnervingly through the whole
lunch hour. But your real kisses,
when they come to me, calm me
like half a valium chased
with beer, so that my convict
heart stops banging its cup
on the bars—because the iron
door has suddenly shuddered open,
and the guard's waving me out,
waving me out with a smile
after all these years.

## Instructions Received in a Dream

Reach as if suddenly wakened.
Touch stone. Feel among its atoms
the empty spaces breathing. Wanderer,
the world is farther than you know!

# Black River

You believe you must be beginning again.
The river opens to accept your first step,
and you're into it up to your knees—
the water's wrestle brotherly, bracing.
You start across, shouldering goods
you believe you'll need on the far side.
Waist-deep now. Feeling for rooted stones
through sopping boots. Surely it was here
you crossed before; there is no abyss, no
unknown channels…though the current
does seem swifter than you remember,
and darker (of course, it's only dusk
coming on, staining the air and water;
and the river—you believe—only seems
to be growing wider). Chest-deep now.
Icy water races past your racing heart,
under raised arms that ache to balance
whatever you carry, what you must (you
suddenly understand) be willing to let go.
Chin-deep. Perched on a slippery stone
that shifts with each shivering breath.
No choice but to take the next step—
deeper into the black river, farther
toward the shore of ink-black pines
over which the feverish stars have risen
and the cold comfort of a bone-white moon.

# Four: The Eye's Reach

# The Cloud and the Kingdom

The blue of the sky can't really match
this blue in your mind. A fact of nature
alludes to nothing within the self.
Yet a moment ago you felt part of it all:
a cloud slipped in between your ribs, bled in
like those whispers in the adjacent room—
a confiding sigh, a swallowed moan.
You looked out the window then,
into the strange day. If you weren't here
for a seminar on the company's dime,
you'd never be in a bedroom alone
in the middle of a bright afternoon.
You'd never wander into this
pleasure, quivering in the feathery
grip of *Magic Fingers*. Or is it
their voices you tingle with? Lovers,
certainly, probably illicit. But desire
is like a landscape. "The vast tract
of unenclosed wild known as Egdon Heath
embrowned itself moment by moment." Wrens
start from nests along sequestered brooks
upon whose ripples the clouds tremble
in a blur of dismemberment. Death
broods in the love-cry, in the moans
of disunion, and the dry act of reference.

Suddenly the mechanical massage is done,
and your bed stills. The bed next door
has stilled, also: ripeness and silence.
A gaping silence. And the blue welkin,
curving away above the powerlines
and the smokestacks of beef-red brick,
is no help. Beside your pocket your cock
has plumped, nuzzling keys and coins—

but you'd rather walk out along the gritty
street, under smog-eaten elms and maples
and those trees with the leathery leaves
whose name never fails to escape you.
*Let all the lovers savor their moment,*
you think. *Let nature pretend.* Only you
shall not pretend. You shall go to the panel
of direct mail experts and sit, your head
attentively bowed, for theirs is the kingdom,
the "real world" your parents spoke of:
a vista of warehouses, office towers,
parking spaces edged by concrete oblongs.
But look: the cloud that kissed into you
"out of the blue" is there…voluptuous
over the service roads and the ditches,
over the sign at the Quality Inn proclaiming
today's topic: "One Hundred Words That *Sell!*"

# Self-Assessment

1) Where do you want to be in five years?
   What do you want to be doing there?
   With whom, and why? How often?

2) Look at your hands. Is there someone
   for whom you would thrust them in fire
   without hesitation? Would you do it gladly?
   Would you be glad to do it in five years?
   (If your hands have been burned already,
   skip down to the next set of questions.)

3) Do you think the world will end in fire?
   Do you think it will end within five years?
   Where do you want to be when it ends?
   What do you want to be doing then?
   With whom, and why? Will you be glad?
   (If you think the world has already ended,
   skip down to the next set of questions.)

4) Where are you? How did you get here?
   What made you come? Look at your hands.
   Think what they've done. Do you feel glad?
   Do you feel frightened? Do you feel free?

5) How often above did you answer yes?
   Tell why in one deep breath or less.

# The Whisper

If he could he'd ask to be blessed with peace,
or at least the sensation of exalted strife—
a Moore figure, or *The Rite of Spring:*
either ripe stillness or riotous flowering.
For between the two his heart is grey;
breath shallow, mind blear, tongue dust.
He'd rather feel his life wash away in blood
than be this thin whisper at the deaf ear of God.

# Forced to Wonder

I

I stand a moment, enmeshed in the past:
see my childish feet in the amber water
of a glacial lake, their skin fish-belly white

and strangely vivid...criss-crossed by sun
as it shivers through the wrinkling surface;
I can feel the frigid stones under my toes,

feel the hardness of their lives in the bones
of my heels; and I squint across the years
against the flashing of those ripples....

II

No matter how truly I try to record it
(pen-tip plying page after page), the hour
when I stood in the shallows of the lake

has faded—as all our memories (freighted
with feeling) will fade; so that I'm forced
to wonder why my heart's aroused...why

these words insist on being written—as if,
by weaving transcience with transcience,
a timeless image might be revealed in time.

# Bronze Bud Vase in the Shape of an Iris Bulb with Swordlike Leaves

On root-strands of twisted metal, it
rises delicate and durable at once,
holding a fresh-cut stem of iris
up for the Bronze Age gods
to smile on or reject with a laugh.
(The gods are cruel; they do not love,
but no love grows without them.)
What will become of this gift?
Through how many years and hands
will it pass, holding how many flowers,
before it returns to the earth? And
the heart that chose it and the hands
that wrapped it in colorful paper—
how many aches and empty gestures
will they suffer, how many joys
and unforgettable embraces,
before they return to the earth?
Nothing is simple. The leaves
of the vase, which are beautiful,
are pointed and cold to the touch.

# The Ghost

> *I know my heart is not enlightened.*
> —Wang Wei

A mist-haunted grove,
the early dusk arrowed
with light left over

from the late Bronze Age.
Sparks of wetness bend
the deer-waded grass

by the creek that threads
among roots like breath
drawn into a loom

of words. Stillness. Then
the mist lifts; sun-warmth
deepens; and a shadow

stretches from my body,
a ghost of brushed-thin ink.
We stand together now

in silence. Overhead,
spent pine cones sway
like broken temple bells.

# The Dyer's Craft

The dyer dips a swatch of linen
into the lukewarm, blackish water,
water smelling of eggs and vinegar,
then withdraws it and peers at it,
deciding it needs to be darker.
No color-wheel tells him so,
no spectral authority in a book.
The cloth in his hand makes plain
what the day's light is hiding—
an absence he needs to announce,
to clothe someone in. Bitter indigo,
two shades past midnight blue.

# The Moonlit Dream

*for Jim Bednar*

The dream's all voices: hers. "The hundred-faced moon," I would say. Moon out of Lorca, and the rest. But the moon's been walked on in my lifetime and can only be dust now, or nostalgia. Still, all I've learned has come through those voices in the moonlit dream, their swaddling textures. Once a friend put on Jimi Hendrix, saying, "I've taught myself to listen till all I can hear are the scratches." Then laughed. "Rock 'n' roll Zen," he grinned, as Hendrix soared into *Foxy Lady*. A fifth of wine later I pressed my cheekbone against the cold linoleum and sank through the basement floor, into the arms of the voices. Far off, some thug was pounding a tin can down over my heart. I wept for my heart among the voices, and their murmuring was a balm to me. "Don't fear the blessing," they sang. "Your soul was meant to be hung in the willows."

# Outing on a Grey Day

*for George McWhirter*

> *Mais l'instant s'allonge /Qui a profondeur.*
> —Guillevic

> *Yet if the intervening film / breaks down, it is death.*
> —D. H. Lawrence

## I
### Through the Marina

This water backed up from
the Fraser River is viscous
as sleep. Upon slippery planks
(lashed to hollow drums) we climb
over sucking, oily ripples
and the creak of fraying knots.
Old nails whimper where we step.
Whatever's sunk here's smeared
by algae—what grim handshake
of withered light?
Only what floats can be
clearly seen: a fish,
bottles, twine, the names of boats
that every gust or raindrop scatters.
Even the kids, hand
in hand with our reflections,
float.          And edging
the narrow inlet, tangled
as genital hair, coils
of barbed wire shiver
with wind, making breath
catch like a ball of down
deep in my chest.

Then, from beyond
the skeletal bridge, a cormorant

wheels wildly upward
and, as a steady drizzle starts,
hangs:

black fingers
spread in the rain.

## II
### *Along the Fraser*

On the seaward current, the cormorant
cranks back its stiletto head—
then unwinds
three quick strikes. Plucked
out like a pulpy root,
the fish flails
but is sucked down neatly.
And squatting on either side,
the kids touch
my trembling knees.
"Hey,"

I breathe. "Can you sail
stones?" (Nearby, George hefts
a stump and waltzes
it away to the bridge road.) Our first
volleys spook the bird, who alights
down river. Flat as footsoles
more rocks skip across the water,
flip, cartwheel and plunge.
(Returning, George waves blackened
fingers and calls: "Pitch
makes a good fire!")
Grown bored, the kids wander off

behind their father. I too would follow,
if the granite did not fascinate

my bones. Instead,
I kneel here and dip
my hands deep: the jealous
river grabs me by the wrists
like a lover.

### III
### *The Bridge*

While George swings firewood
into his car, I wander
on the bridge.

Below, the choked
inlet's iron water.

And floating on a thicket
of rusted wire, another cormorant:
eye of black grease, beak
half-parted like a spent pod,
feathers fingered slick
by rain.         In its cold
habitat, like a sleeper
swallowed by his bed, I sweat
darkness; vertigo climbs
the thermometer of my throat; spine
willowy as a mangled wing....
I feel I can't turn
back. But calling, George
waves me back.

And I return.

### IV
### *Driving Home*

The road under my hunched
body rivers, the ghosted

landscape streaming
over the glass
skin of my reflection.
The fragrance of George's
sap-streaked jacket ripens
the car. *You navigate
time,* its wheels
seem to mutter. *What matters
is the eye's reach into all
it can't grasp:
water; light; this earth
you'll enter and enter until
there's no leaving it.*
Suddenly, the kids
point from the back seat:
"Look!"

Above the road, a slowly
turning wheel of birds,
the low sky splitting
open as we watch
into canyon on canyon
of radiant white.
And at the flute end
of space:

SUN.
       A numbed
clutch of roots catches
fire in my skull. Like birds
the leaves of my vision
rise up…riding the secret
currents in the air.

# On a Used Copy of Witter Bynner's Translation of the *Tao Teh Ching*

*for David Lachman*

These cigarette ashes smudged
into the gutters of my book
call to mind the one who read,
smoked, contemplated—dog-earing
certain pages, meaning to return.
The copyright notice is 1944:
*This is a John Day Wartime Book.*
"The sanest man," says this Laotzu,
"takes everything as it comes,
as something to animate,
not to appropriate." Brother,
sister—do you still breathe,
I wonder? Or have you returned
to the root the whole world
flowers from? This book
you lost or mindfully set adrift
discovered me, as it will someday
surely discover others; and since
I breathe, I offer your shadow
this poem as thanks—these words,
these smudges of ash....

# Five: Brightness and Shadow

# Dawn Rain

At first light, the sky
scatters an abundance
of beaded wetness down
through June leaves,
into lush grass.

Listening, I can hear
your quick breath again,
feel it kissing my ear
until I shiver...
drenched in memory.

And awhile later—sun:
soaked roots lifting
grass-blades and blossoms,
your name flowering
under my breath:

an abundant sound.

## **Seduction**

The mind has a way
of wandering
most when you least
expect it. There it goes,

off the edge, avoiding this
obvious line your eye
dutifully follows—
to what end? To wherever

past each forest a bridge
reaches, then a wall, walls
and roofs. So before you
know it the mind is

lost in the world, and we
are alone in this dark
room together: nothing
but breathing between us.

## Standing By

This woman who has lost so much—
mother love, job, pleasure in her body—
kneels by the grave while I stand by
in case I am called. Now she is speaking
toward the earth healed over by grass.
I am moved, but wonder why she speaks.
"The one you seek is not here." I watch
intently, standing by, but it's no help.
She is as alone in my looking as I
am alone in the shadow of her loss.

# The Blue

> *In memory of Michael Nigg,*
> *April 28, 1969–September 8, 1995*

The dream refused me his face.
There was only Mike, turned away;
damp tendrils of hair curled out
from under the ribbed, rolled
brim of a knit ski cap. *He's hiding*

*the wound,* I thought, and my heart
shrank. Then Mike began to talk—
to *me,* it seemed, though gazing off
at a distant, sunstruck stand of aspen
that blazed against a ragged wall

of pines. His voice flowed like sweet
smoke, or amber Irish whiskey;
or better: a brook littered with colors
torn out of autumn. The syllables
swept by on the surface of his voice—

so many, so swift, I couldn't catch
their meanings...yet struggled not
to interrupt, not to ask or plead—
as though distress would be exactly
the wrong emotion. Then a wind

gusted into the aspen grove, turned
its yellows to a blizzard of sparks.
When the first breath of it touched us,
Mike fell silent. Then he stood. I felt
the dream letting go, and called,

"Don't!" Mike flung out his arms,
shouted an answer...and each word
shimmered like a hammered bell.
(Too soon the dream would take back
all but their resonance.) The wind

surged. Then Mike leaned into it,
slipped away like a wavering flame.
And all at once I noticed the sky:
its sheer, light-scoured immensity;
the lavish tenderness of its blue.

# After the Service

*for Ed Osborn*

The cottonwood and the maple
planted side by side, so close

their leafy boughs mingle. They
weave their own green stories

in the breeze; but together,
make a more rapturous noise—

the sound that makes him glance
upward and grin, though still

heart-sore from the funeral.
"She's here," he murmurs, love

kneeling in his voice. "Listen.
I think she's all around us."

# Flashes

After sundown, lightning; then some
goatfooted drunk dancing on the roof.
Irregular spatterings of rain paste
shreds of leafgreen to my window,
which glow—their undersides ghostly—
even though my lamp is off. Nothing
that's not sodden, not autumnal....
Yet I love autumn! And yet
it's not autumn, but the decline
of a summer come nearly to nothing,
a season balanced on the cliff-edge:
this windowsill where I've planted
my elbows to watch the panicky
storm as it happens, to squint
into those breathtaking flashes
by which I see I must learn to see.

# Starlings

The oaks are possessed by starlings. Their branches sway heavily like the outstretched arms of sleepwalkers. Now and then, as if startled, trilling clouds of singers swirl up, rush over the roofs, and find farther trees...scattering down....

Soon the whole neighborhood resounds like a festival of choirs!

This music is naked, exalted, hypnotic...a mob of waves pounding sandy cliffs inside us. And yet we can hear, in each bird's voice, the silent sky it wanders at night—alone—with its beak buried under its wing....

# **Daybreak**

    Sun, liquid on
           the east horizon,
      apricot fire
dripping

       from twigs, smeared on
grey panes, gilding cold
    drops that quiver
        (hung from

the steel clothesline).
    Be still. Let us stand
       here a moment,
  muted:

 feel the clean light
spill through eyes and pores
    into the heart's
       drained cup.

# A Midsummer Night's Tennis Match

*for Joe Nigg*

We're swatting balls
under the floodlights,
over the net (pang
of taut racket strings,
pang in the arm, the heart);
sweat lacquers our backs
in the midnight heat.

The game: to be here
at every stroke, aiming
beyond each other's reach.
The cardinal rule: honor
the lines drawn by others,
their odd ordering of points—
Love, 15, 30, 40—when zero,
one, two, three would do.
And what's this swatting
and sweating for? The night
beyond the light is deep,
and the lines enclose
an emptiness. Yet

the court is a field
where grace appears—not
springing from a score alone,
nor only from strokes perfected,
but from the pangs. Amazing
grace in the rightness
of the pangs.

# Brightness and Shadow

> *Gone*
> *the sweet agitation of the breath of Pan.*
> *—Robert Lowell, "Suburban Surf"*

She couldn't stay, so he's up with the sun.
He drifts room to room and collects the candles,
vanilla and spice-scented, and cinnamon,
and wildflower, and puts them away.
He snaps shut the oil-bottle's cap (it leaves
a mild fragrance of hyacinth on his fingers)
and twists shut the can of iris-scented talc,
then finds under the sofa the camelhair brush
he used to brush the powder over her breasts,
stomach, hips: all these he puts away. Then
the cassettes they played while making love,
while bantering and laughing, he returns
to their plastic cases, and puts the cases away.
He washes the wineglasses and puts them away.
Then he makes some coffee, toasts some bread,
and sits down to eat...but finds himself
staring out into the courtyard. Rough
wind shakes all the new-leafed branches:
a thrash of green brightness, green shadow.
Yesterday, lying naked near the balcony door,
she followed a blossoming cloud and talked
of childhood; they touched playfully, kissing,
stroking, half-wrestling, tenderly biting....
The memory shakes him like a leafy bough.
Sweet agitation: brightness and shadow.

# Summit

At times, the trail we've climbed
turned so steep we wandered lost
inside our bodies' ache; or lost
sight of each other at certain
creekbeds or switchbacks,
the path overgrown or erased
altogether…and the two of us
finally drawn onward by nothing
but the thread of our breathing
and the knowledge that both
were still climbing…until
suddenly now here we stand,
leaning together in tired silence:
black peaks, the moon a dollop
of snow; and below, the stars
of home lights scattered beyond
the empty valley we started from,
shining farther than the eye can see.

# Glassbottom Boat

She has dozed off beside me on the couch after making love. Candlelight kisses through the half full wineglass, trickles rosily over her skin. I can't take my eyes off her face: relaxed but not passive...peaceful, though her eyes swim rapidly under their smooth lids. She is watching tropical fish through a glassbottom boat. They dart about like sparks in the depths. She is on vacation; there are no phones, no schedules. *Joy is having time,* I think. *And time to waste.* I can't believe those fish! Their neon colors: chartreuse, tangerine, indigo, jade; even the black ones shine. Our hands touch, the fingers interlace. Our boat rocks gently in the sleepy Caribbean sun.

# The Rain at Midnight

Here I am pretending to sleep, but in truth
I'm eavesdropping on the chattering rain,
hearing it gossip in multiple voices
like three beautiful sisters

after dinner, the dessert half-eaten
now that the talk has turned to miseries
of marriage, and bewildering children,
and mothers who knew no better—

and I wonder if they understood
I'm not really asleep, if they felt
my male listening alive in the bright
circle of their concerns…how

they might take it, whether they'd fall
silent, or just go on a bit louder,
a touch more forcefully, knowing I'm there,
knowing who's lurking in their midst—

or maybe they'd simply blend back
into rain, a dark rain, the lull of it,
the sweet nothing noise and the kiss of it,
the tears and the healing sleep of it at last.

# Notes to the Poems

*Dedication:* The quotation is from Hayden Carruth's *From Snow and Rock, From Chaos: Poems 1965–1972* (New Directions, 1973).

Page 12: Evelyn Nesbit (1884–1967) was an actress and the mistress of New York architect Stanford White, who was eventually murdered by her husband, Harry K. Thaw. Their story was the basis of the 1955 film, *The Girl in the Red Velvet Swing*, and was used by E. L. Doctorow in his novel, *Ragtime*. Before her notoriety, Nesbit's image was used in the vintage Coca-Cola advertising to which this poem refers.

*Page 49:* Depoe Bay is on the Oregon Coast.

*Page 52:* This poem responds to an actual broadcast. Of course, the nationalities mentioned could all too easily be changed to reflect a hundred other broadcasts detailing other, equally heart-numbing atrocities.

*Page 65:* The quotation in stanza one is from the first sentence of Thomas Hardy's novel *The Return of the Native*.

*Page 71:* The Tang Dynasty poet, physician, and painter, Wang Wei (699–759 C.E.) was an approximate contemporary of Li Po and Tu Fu. The epigraph is from the poem "Suffering From Heat," translated by Tony Barnstone, Willis Barnstone, and Xu Xaixin in *Laughing Lost in the Mountains: Poems of Wang Wei*, easily the finest collection of Wang Wei's poems in English.

*Page 74:* The first epigraph draws from Guillevic's poem "Durée" and may be translated, "But the moment grows longer/that happens in depth." The second epigraph is from Lawrence's chapter on Edgar Allen Poe, in his *Studies in Classic American Literature*.

*Page 78:* This poem's unconventional spelling of "Laotzu," reputed author of the *Tao Teh Ching*, preserves Mr. Bynner's usage.

# About the Author and Acknowledgments

Joseph Hutchison is the author of *Bed of Coals* (winner of the 1994 Colorado Poetry Award), *House of Mirrors*, *The Undersides of Leaves*, and the 1982 Colorado Governor's Award volume, *Shadow-Light*. He teaches for the University College at the University of Denver and lives with his wife, Melody, in Indian Hills, Colorado.

*American Literary Review*: "Christmas Parade" *The Bastard Review*: "The Shower" *Calliope:* "Bare Maple" and "The Music of Change" *Communiqué:* "Flashes" *Crosscurrents:* "The One-Armed Boy" *Denver Quarterly:* "Forgone Conclusions" *Hubbub*: "Daffodils" and "Seduction" *Hurãkan:* "After the Service" *Luna:* "White Owl" and "The Dyer's Craft" *Midwest Quarterly (The Great Plains Issue)*: "The Ghost" *Northeast*: "A Beach North of Depoe Bay," "Bending Over My Reflection," and "A Midsummer Night's Tennis Match" *Poetry (Chicago)*: "Black River," "Standing By," "Sundown" and "What I Know" *Poetry Now*: "Remedies" *The Portland Review*: "A Natural History" *Riverstone:* "What Keeps Me Here" *Seems:* "The Rain at Midnight" *Tar River Poetry*: "Self-Assessment" *Writers' Forum*: "Blossoms," "The Dreamers," "Instructions Received in a Dream" and "The Net" *Zone 3*: "Evening on Loveland Pass"

"Self-Assessment" also appeared in *Tar River Poetry Twentieth Anniversary Issue* (1998), a retrospective collection of work published between 1978 and 1997.

"The One-Armed Boy" also appeared in *The Anthology of Magazine Verse and Yearbook of American Poetry, 1985* (Monitor Books, 1986) and in the anthology *Pierced by a Ray of Sun* (HarperCollins, 1995).

"Walking Off a Night of Drinking in Early Spring" appeared in *Luna: Myth and Mystery*, by Kathleen Cain (Johnson Books, 1991) and in *Crossing the River: Poets of the Western United States* (Permanent Press, 1987).

The following poems appeared in *Wandering Music* (The Juniper Press, 1990): "One Way Fare" and "The Tremor."

The following poems appeared in the chapbook *Sweet Nothing Noise* (Wayland Press, 1991): "Apartment House Midnight," "Bare Maple," "Dusk," "Family Planning," "Flashes," "Glassbottom Boat," "Masks," "The Moonlit Dream," "Punishment," "Radiance" (under the title "Breast of Cloud"), "The Rain at Midnight," and "What Keeps Me Here." Also, an early version of "Palimpsest" (under the title "Autumn's Promise").

The following poems appeared in *House of Mirrors* (James Andrews & Co., Publishers, 1992): "Good," "Internal Combustion," "Walking Off a Night Of Drinking in Early Spring," and "After All These Years."

The following poems appeared in *The Heart Inside The Heart* (Wayland Press, 1999): "Evening on Loveland Pass," "A Natural History," "Blossoms," "The Ghost," and "Seduction."